LOVE IS A
MUTT

summersdale

LOVE IS A MUTT

An Hachette UK Company
www.hachette.co.uk

Summersdale Publishers Ltd
Part of Octopus Publishing Group Limited
Carmelite House
50 Victoria Embankment
LONDON
EC4Y 0DZ
UK

www.summersdale.com

Printed and bound in China

ISBN: 978-1-80007-191-9

Substantial discounts on bulk quantities of Summersdale books are available to corporations, professional associations and other organizations. For details contact general enquiries: telephone: +44 (0) 1243 771107 or email: enquiries@summersdale.com

Frisbee is a registered trademark of the Wham-O toy company.

❤ INTRODUCTION ❤

Welcome to the joyful world of mixed and cross-breed dogs. Just because they're not pedigrees doesn't make them any less loyal, loving or pure of heart. And, let's face it, a mix of breeds nearly always adds up to a lot more scruffly cuteness and adorable quirkiness than a pure-breed anyway! So prepare to take these gorgeous mutts into your heart and enjoy this celebration of some of the best jumbled-up pups the world has to offer.

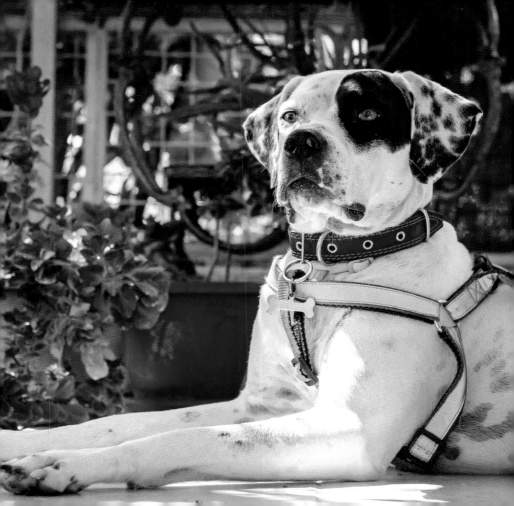

THE BEST FRIENDS
COME WITH FOUR
❤ LEGS AND A ❤

WET NOSE

HE WA'N'T NO COMMON DOG, HE WA'N'T
NO MONGREL; HE WAS A COMPOSITE.
A COMPOSITE DOG IS A DOG THAT
IS MADE UP OF ALL THE VALUABLE
QUALITIES THAT'S IN THE DOG BREED.

Mark Twain

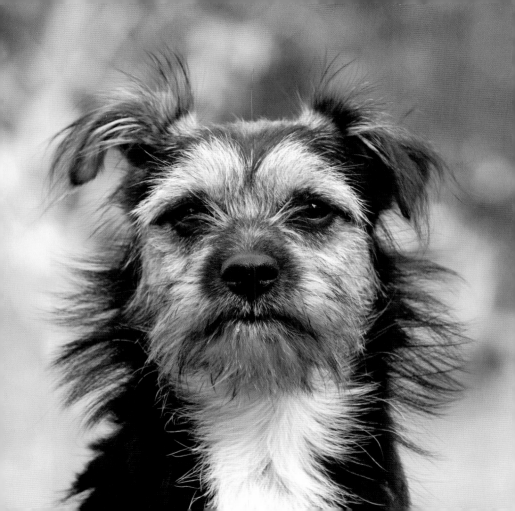

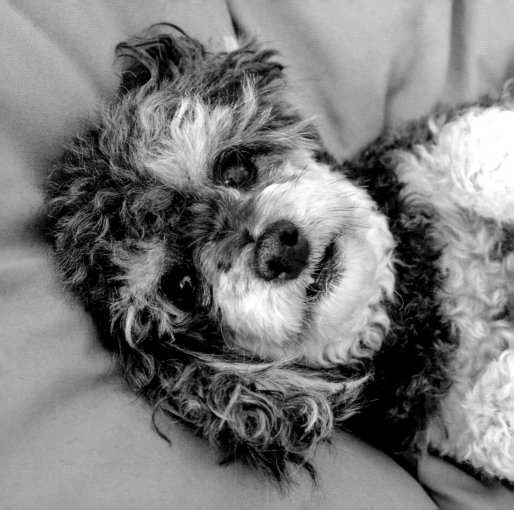

FIRST I STEAL
YOUR HEART,
♥ THEN I STEAL ♥
YOUR BED

WHOEVER SAID YOU CAN'T BUY HAPPINESS FORGOT LITTLE PUPPIES.

Gene Hill

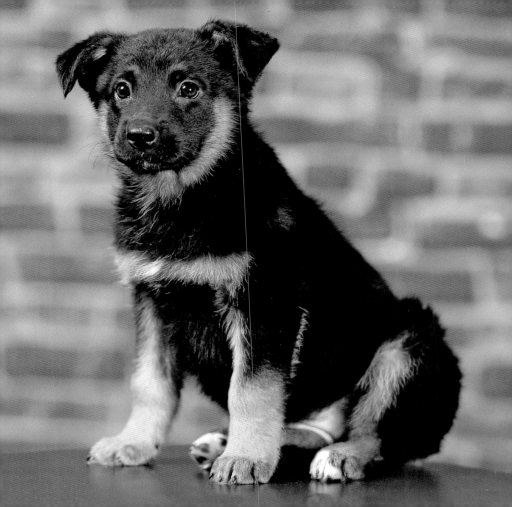

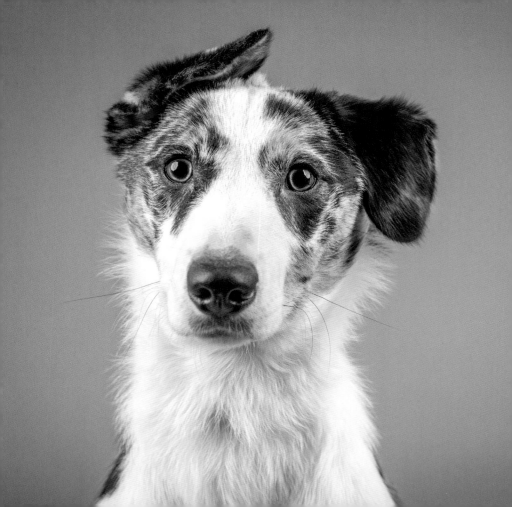

♥ PLEASE, NO ♥

PUP-ARAZZI

EVERYTHING I KNOW, I LEARNED FROM DOGS.

Nora Roberts

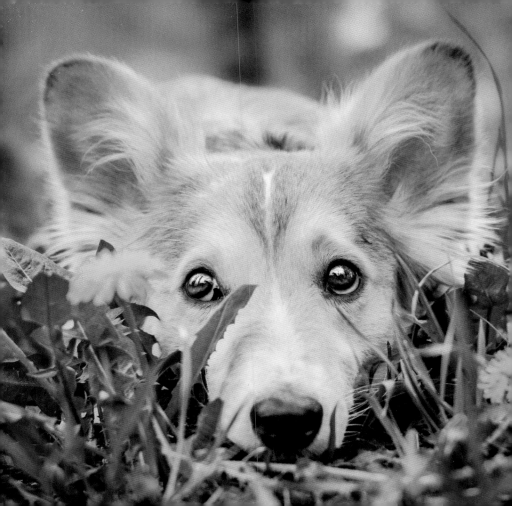

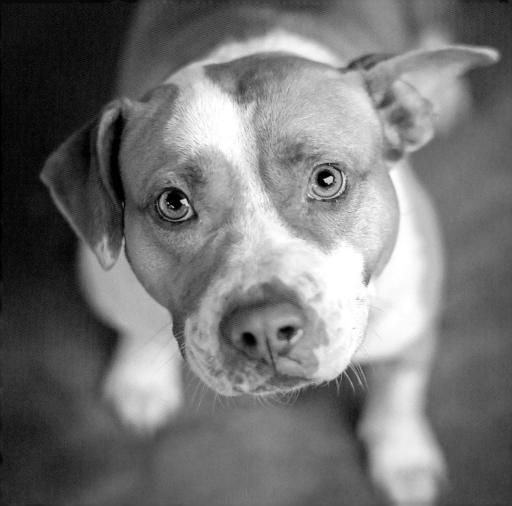

BEFORE YOU GO IN
THE LIVING ROOM, YOU
♥ SHOULD KNOW THAT ♥

I LOVE YOU

YOU THINK DOGS WILL
NOT BE IN HEAVEN?
I TELL YOU, THEY WILL BE
LONG BEFORE ANY OF US.

Robert Louis Stevenson

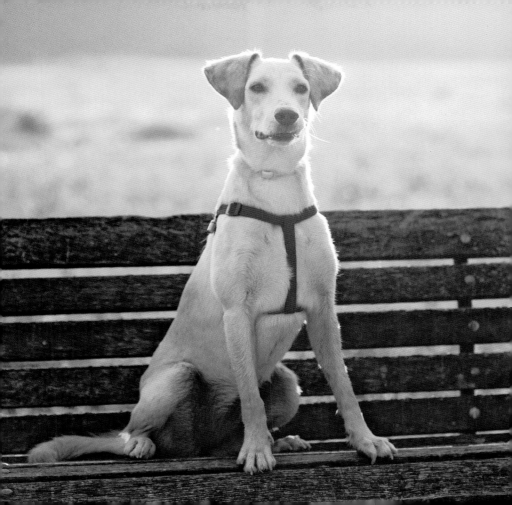

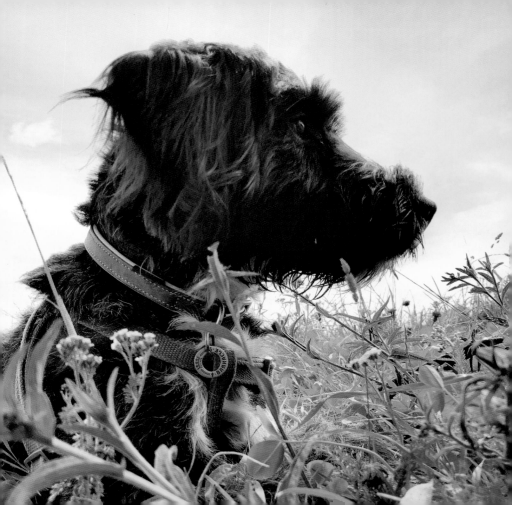

WHAT DID
WE DO TO
♥ DESERVE ♥

DOGS?

MY LITTLE DOG —
A HEARTBEAT AT MY FEET.

Edith Wharton

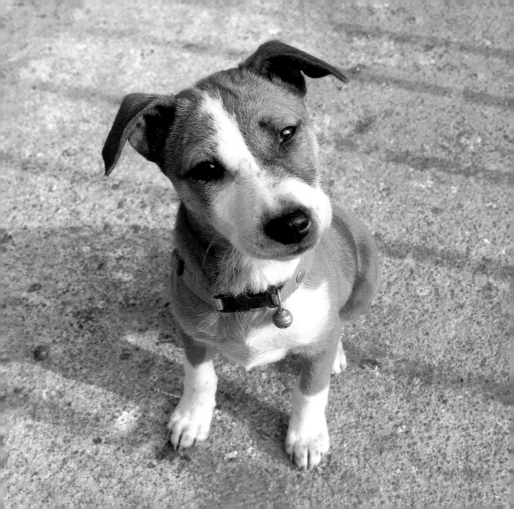

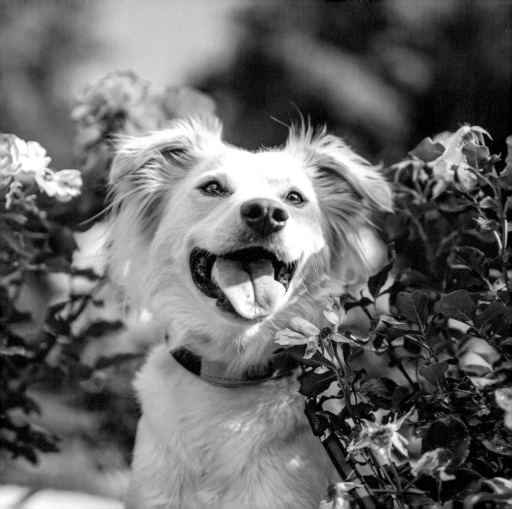

ALWAYS MAKE TIME

♥ TO STOP AND ♥

SMELL THE ROSES

YES, HE'S GOT ALL THEM DIFFERENT
KINDS OF THOROUGHBRED BLOOD IN
HIM, AND HE'S GOT OTHER KINDS
YOU AIN'T MENTIONED AND THAT
YOU AIN'T SLICK ENOUGH TO SEE.

Don Marquis

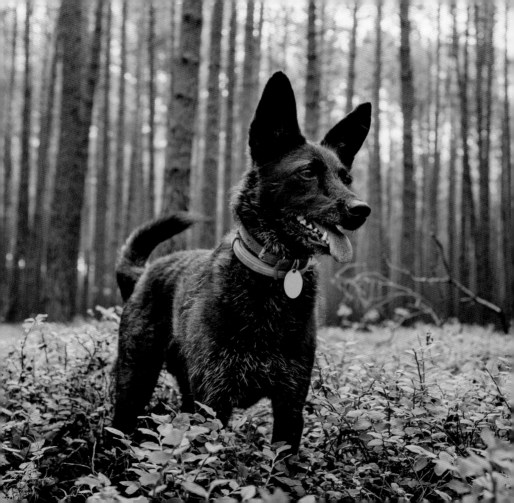

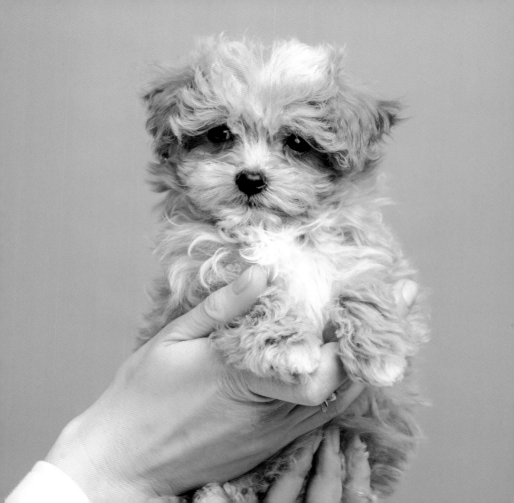

THE BEST THINGS

♥ COME IN SMALL ♥

PUP-AGES

A WELL-TRAINED DOG WILL MAKE
NO ATTEMPT TO SHARE YOUR LUNCH.
HE WILL JUST MAKE YOU FEEL SO
GUILTY THAT YOU CANNOT ENJOY IT.

Helen Thomson

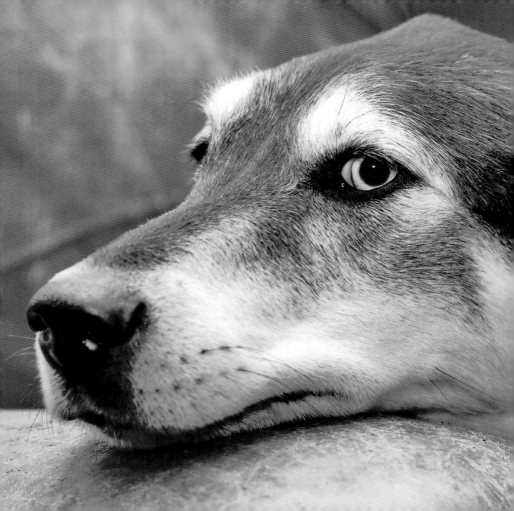

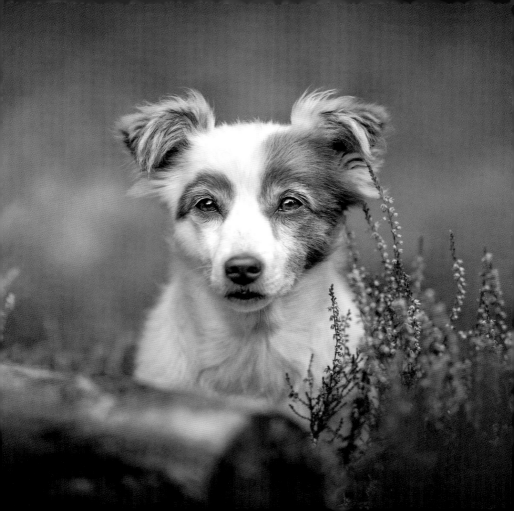

LOOK DEEP INTO
MY EYES... YOU
♥ REALLY WANT TO ♥

BUY ME A BONE...

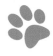

THE GREAT PLEASURE OF A DOG IS
THAT YOU MAY MAKE A FOOL OF
YOURSELF WITH HIM AND NOT ONLY
WILL HE NOT SCOLD YOU, BUT HE
WILL MAKE A FOOL OF HIMSELF TOO.

Samuel Butler

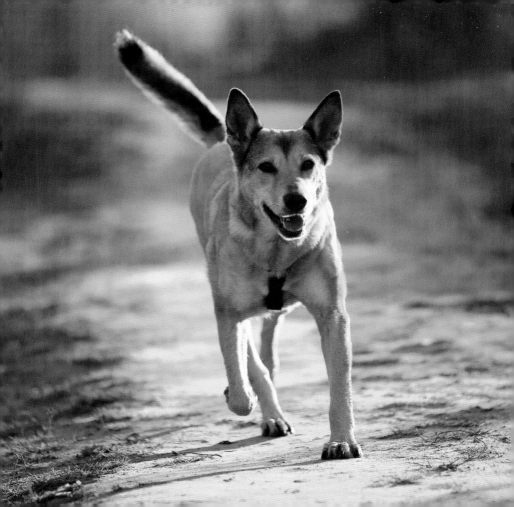

EVERY DOG HAS ITS DAY...

❤ TO ZOOM THROUGH ❤

THE LEAVES!

A MUTT IS COUTURE —
IT'S THE ONLY ONE LIKE
IT IN THE WORLD, MADE
ESPECIALLY FOR YOU.

Isaac Mizrahi

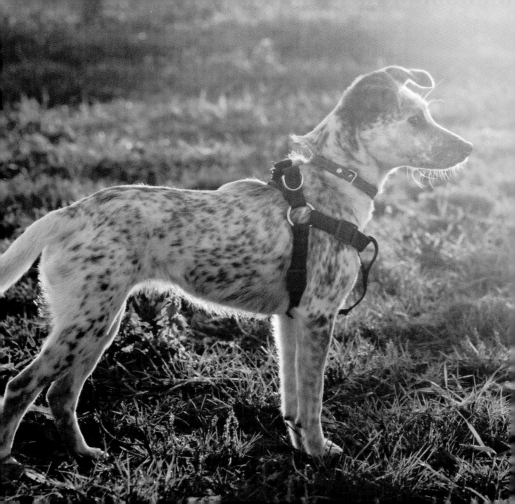

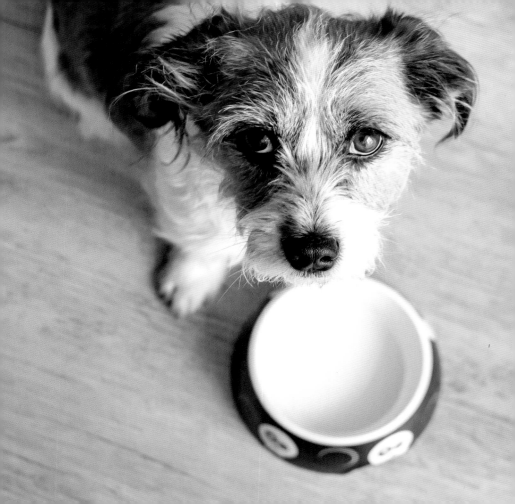

PLEASE, SIR,

 I WANT

SOME MORE

I AM I BECAUSE MY LITTLE DOG KNOWS ME.

Gertrude Stein

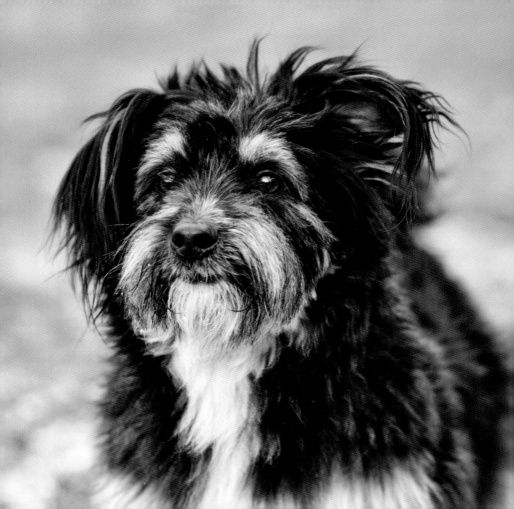

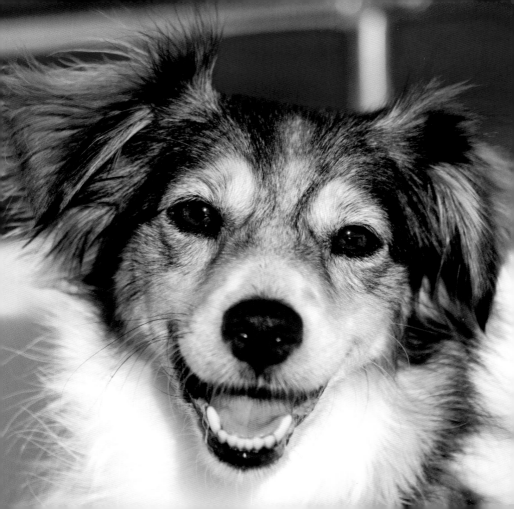

WHOEVER SAID DIAMONDS
ARE A GIRL'S BEST FRIEND
❤ OBVIOUSLY NEVER ❤

HAD A DOG

A DOG IS THE ONLY THING ON EARTH THAT LOVES YOU MORE THAN HE LOVES HIMSELF.

Josh Billings

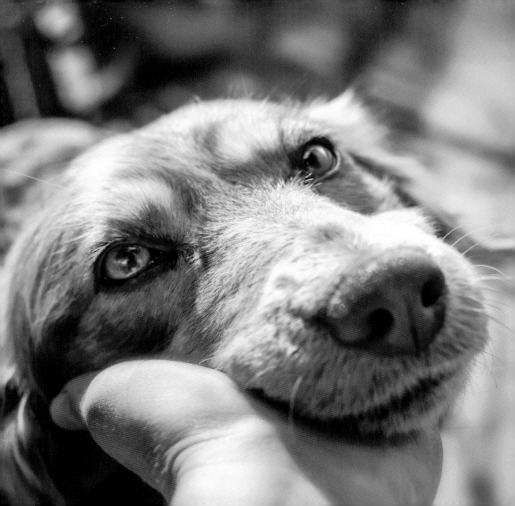

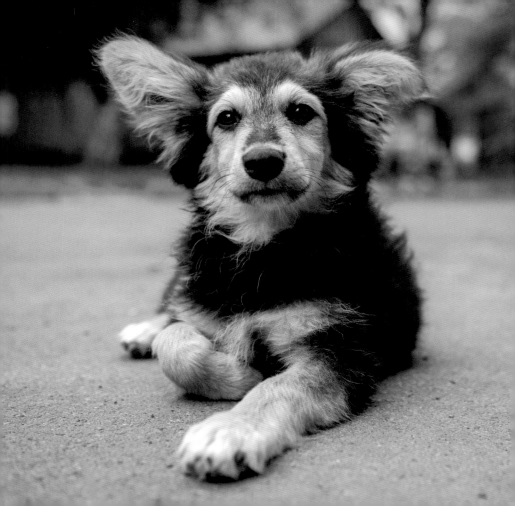

FEARLESS, FAITHFUL,
FUN-LOVING...
AND JUST A
♥ LITTLE BIT ♥

FLUFFY

DOGS ARE MIRACLES WITH PAWS.

Susan Ariel Rainbow Kennedy

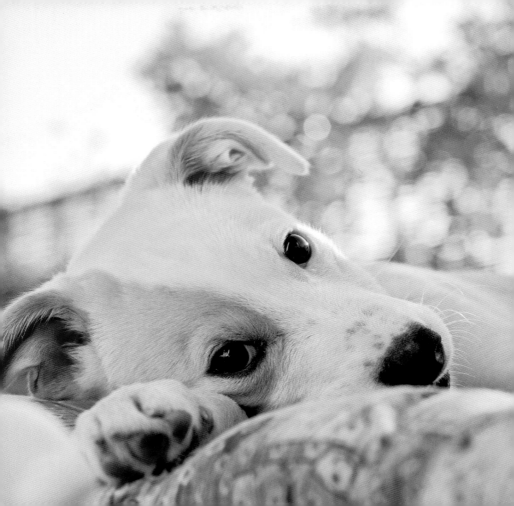

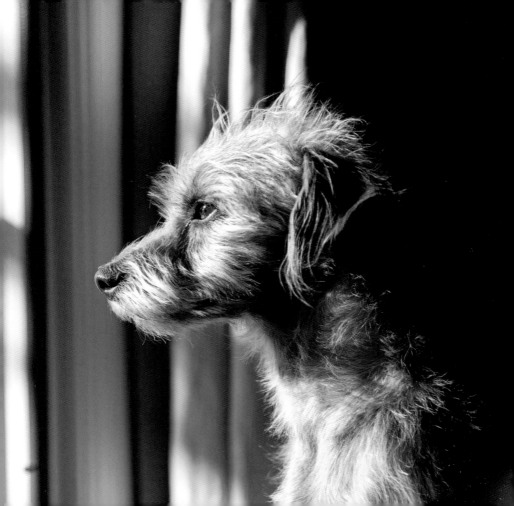

WHAT IF I NEVER FIND ♥ OUT WHO'S THE ♥

GOOD BOY?

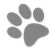

"I'M NOT ALONE,"
SAID THE BOY.
"I'VE GOT A PUPPY."

Jane Thayer

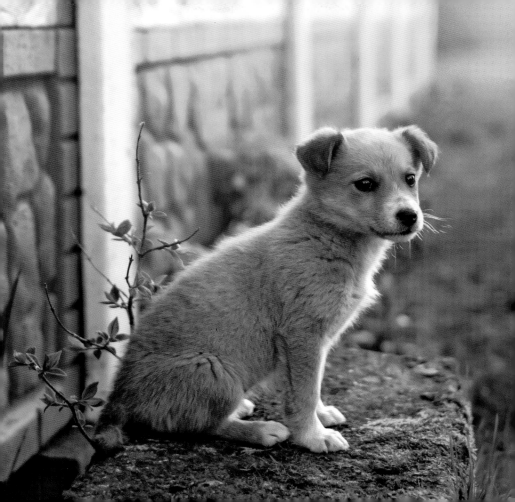

SWEET DREAMS

ARE MADE OF

FRISBEES

FROM THE DOG'S POINT OF VIEW, HIS MASTER IS AN ELONGATED AND ABNORMALLY CUNNING DOG.

Mabel L. Robinson

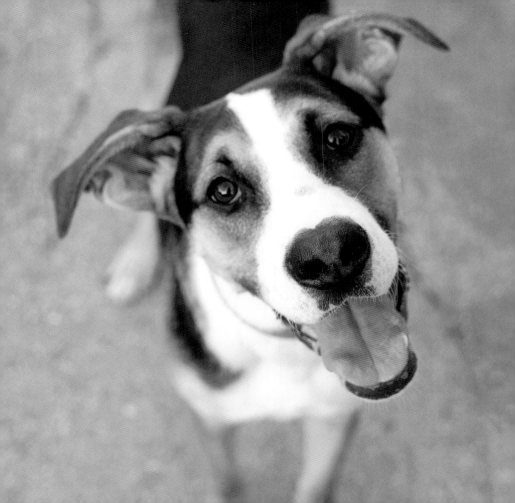

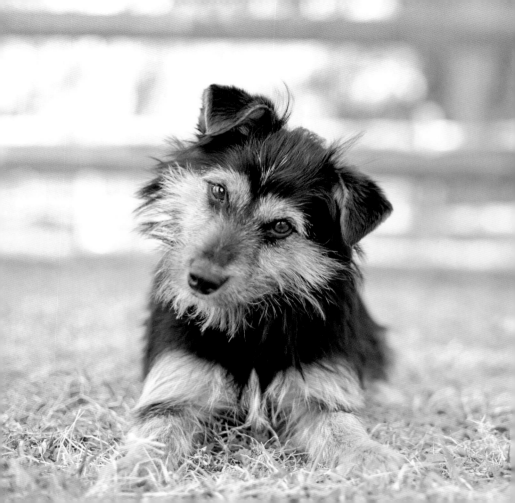

♥ DID SOMEONE SAY ♥

SAUSAGES?!

A DOG IS A BUNDLE OF PURE LOVE, GIFT-WRAPPED IN FUR.

Andrea Lochen

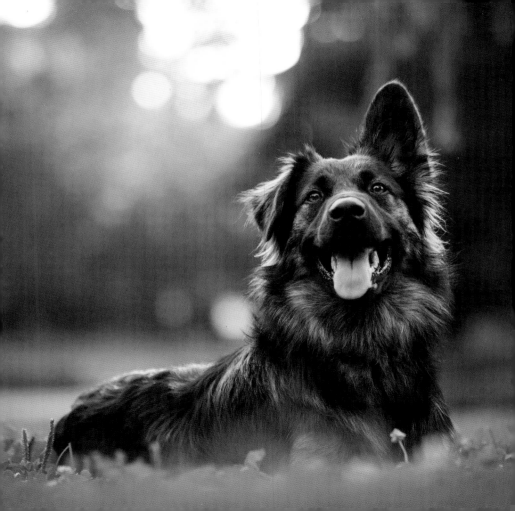

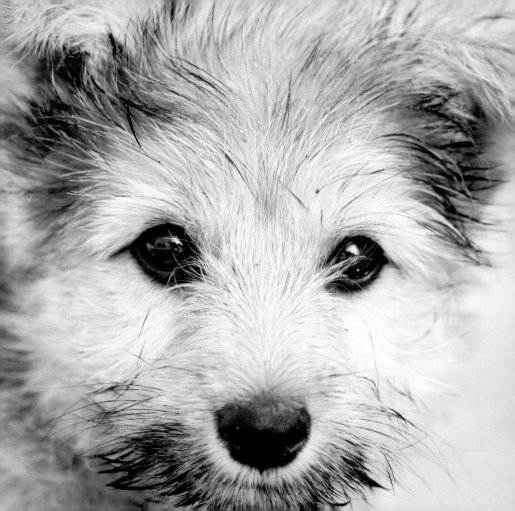

I THINK THEY

♥ CALL THIS ♥

PUPPY LOVE

THE DOG WAS CREATED SPECIALLY FOR CHILDREN. HE IS THE GOD OF FROLIC.

Henry Ward Beecher

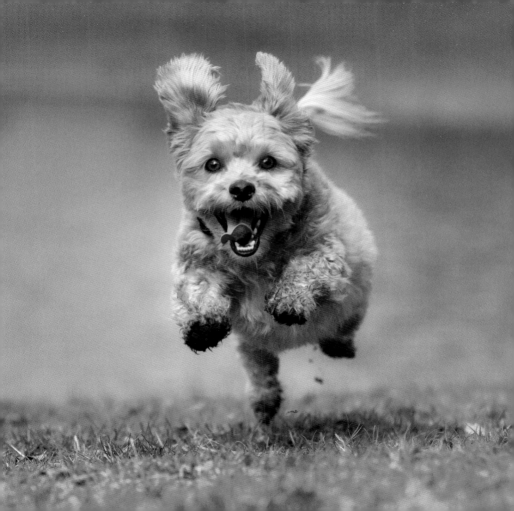

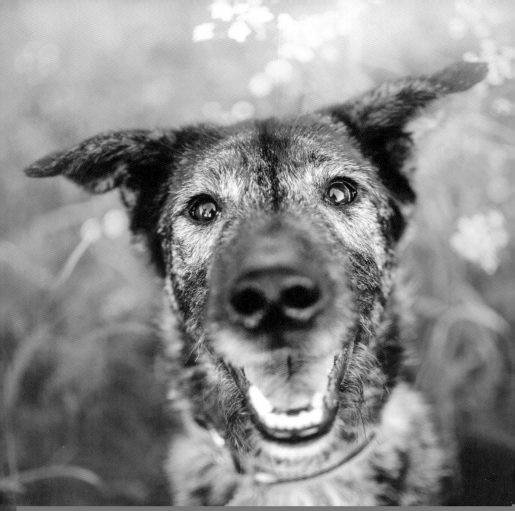

HELLO THERE!
♥ IS THAT ♥

SANDWICH

FOR ME?

THE GIFT WHICH I AM SENDING
YOU IS CALLED A DOG, AND IS
IN FACT THE MOST PRECIOUS AND
VALUABLE POSSESSION OF MANKIND.

Theodorus Gaza

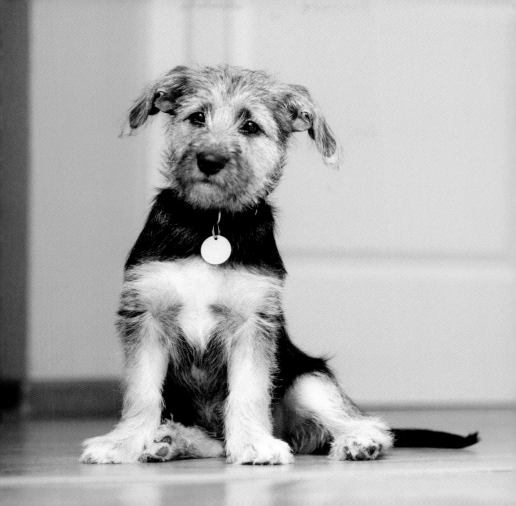

THIS OLD DOG

♥ ALREADY KNOWS ♥

ALL THE TRICKS...

THE AVERAGE DOG IS A NICER PERSON THAN THE AVERAGE PERSON.

Andy Rooney

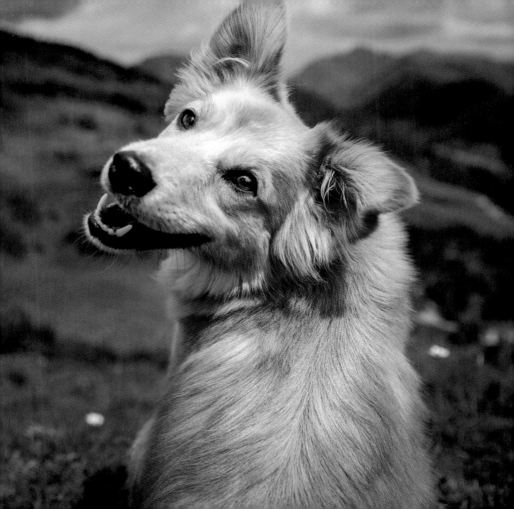

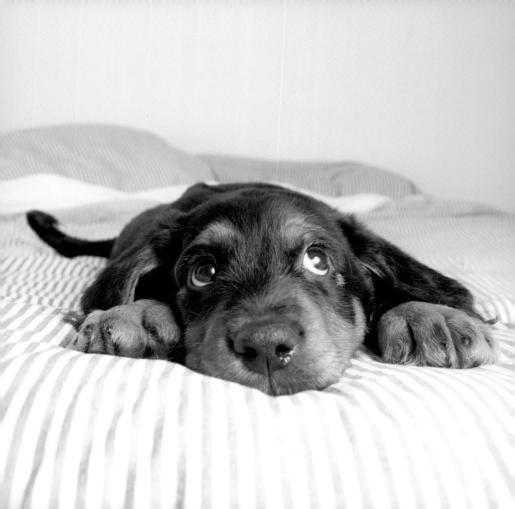

I'M JUST

WARMING ♥

YOUR BED

FOR YOU

IF I COULD BE HALF THE PERSON MY DOG IS, I'D BE TWICE THE HUMAN I AM.

Charles Yu

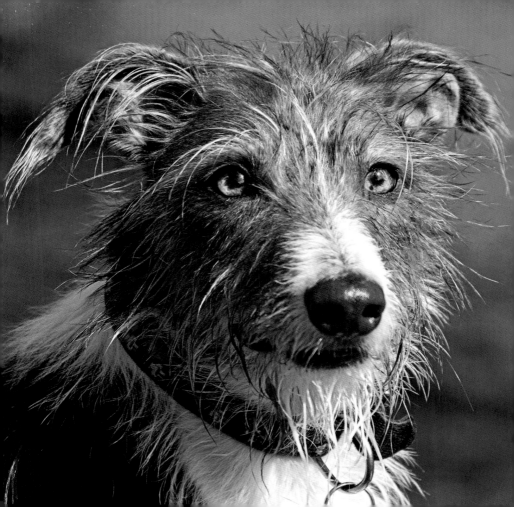

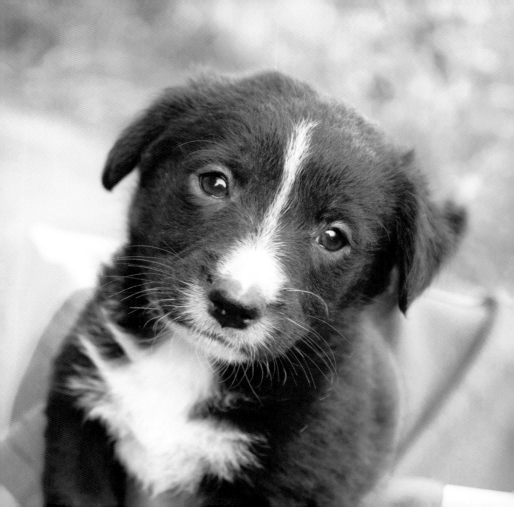

NO MATTER HOW SMALL YOU MAY BE, IF YOU REACH FOR YOUR DREAMS, ANYTHING IS ♥ PAW-SSIBLE! ♥

NO ONE APPRECIATES THE VERY SPECIAL GENIUS OF YOUR CONVERSATION AS THE DOG DOES.

Christopher Morley

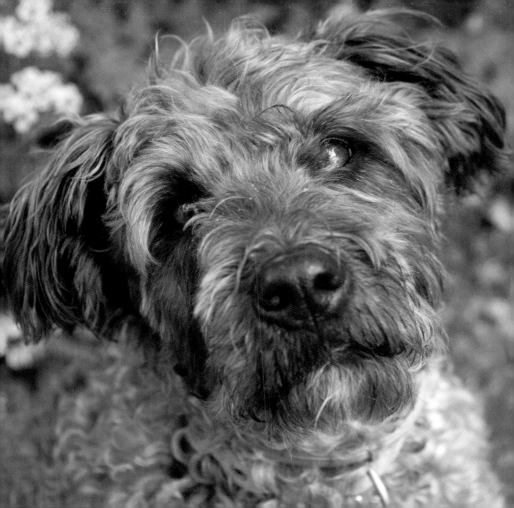

YOU KNOW, THAT
♥ BALL ISN'T GONNA ♥

THROW ITSELF!

A PUPPY IS BUT A DOG, PLUS HIGH SPIRITS, AND MINUS COMMON SENSE.

Agnes Repplier

GET DOWN?

♥ WHAT WAS ALL ♥
THAT ABOUT LETTING
SLEEPING DOGS LIE?

NO MATTER HOW LITTLE MONEY AND
HOW FEW POSSESSIONS YOU OWN,
HAVING A DOG MAKES YOU RICH.

Louis Sabin

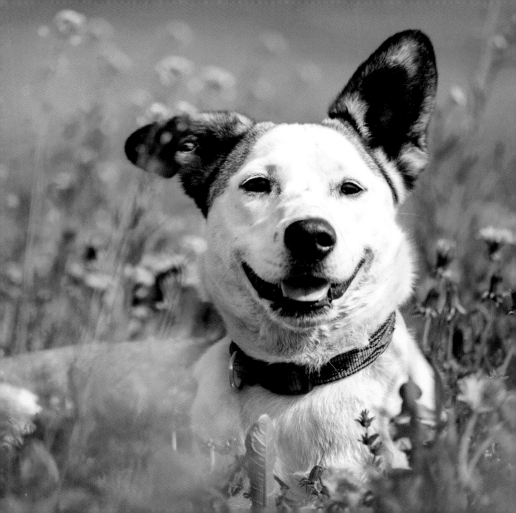

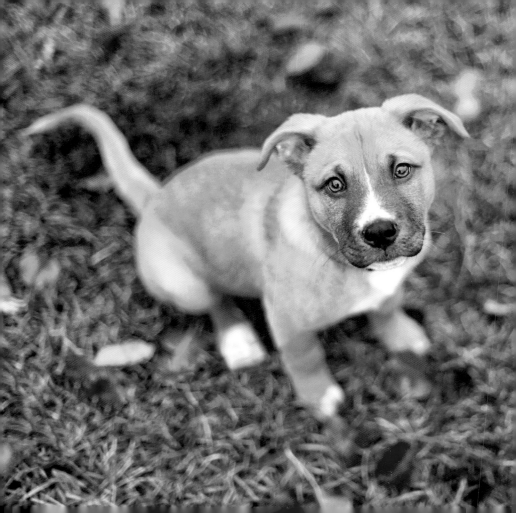

HOME IS
WHERE YOUR
MUTT IS

DOGS ARE NOT OUR WHOLE LIFE, BUT THEY MAKE OUR LIVES WHOLE.

Roger Caras

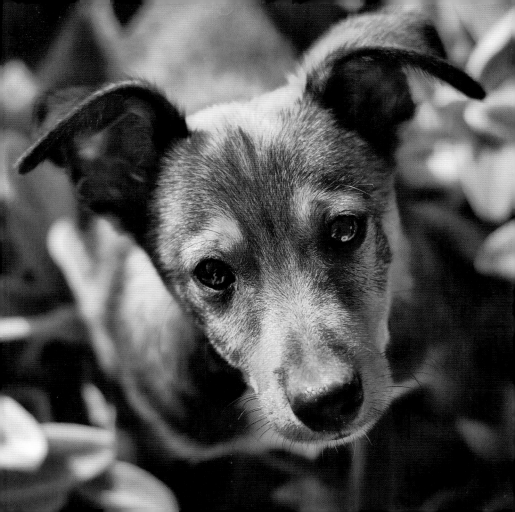

Have you enjoyed this book? If so, find us on Facebook at **Summersdale Publishers**, on Twitter at **@Summersdale** and on Instagram at **@summersdalebooks** and get in touch. We'd love to hear from you!

www.summersdale.com

IMAGE CREDITS